Garden of Life

A Soul Inspired Coloring Book

Copyright © 2016 by Sweet To The Soul Ministries
All rights reserved.

www.SweetToTheSoul.com

Illustrations: Copyright © 2016 Jana Kennedy-Spicer

Cover Design by: Jana Kennedy-Spicer
Interior Design by: Jana Kennedy-Spicer

ISBN-13: 978-1540780027
ISBN-10: 1540780023

No part of this publication may be reproduced, distributed, or transmitted in any form or by any means, including photocopying, recording, or other electronic or mechanical methods, without the prior written permission of the publisher, except in the case of brief quotations embodied in critical reviews and certain other noncommercial uses permitted by copyright law. For inquiries and permission request, contact through website: www.SweetToTheSoul.com

CreateSpace Independent Publishing Platform, North Charleston, SC

Unless otherwise noted, all scripture quotations are taken from The Holy Bible, English Standard Version ("ESV®") Copyright © 2001 by Crossway, a publishing ministry of Good News Publishers. Used by permission. All rights reserved. ESV Text Edition: 2011

Scripture taken from The Message ("MSG"). Copyright © 1993, 1994, 1995, 1996, 2000, 2001, 2002. Used by permission of NavPress Publishing Group.

garden OF LIFE

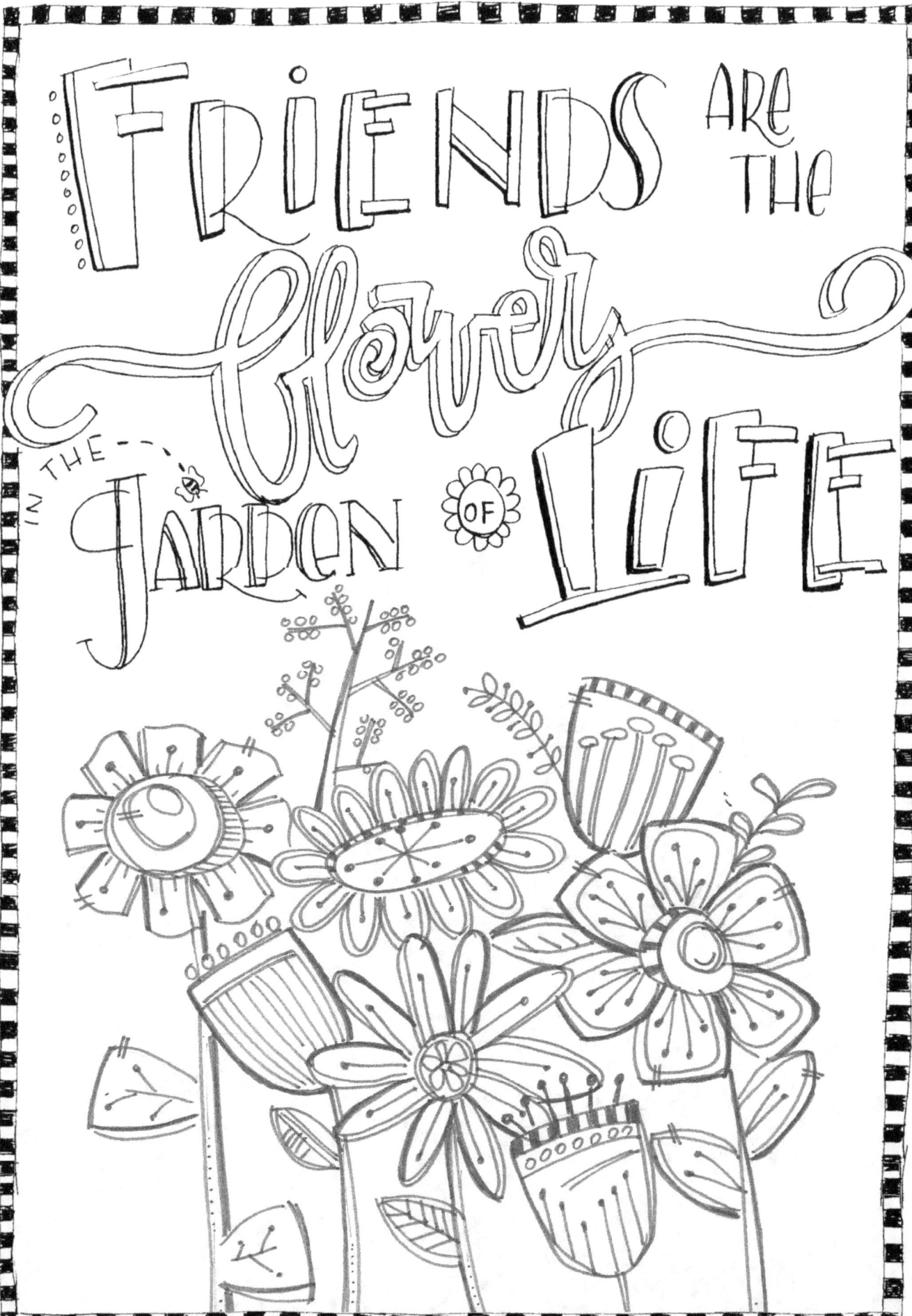

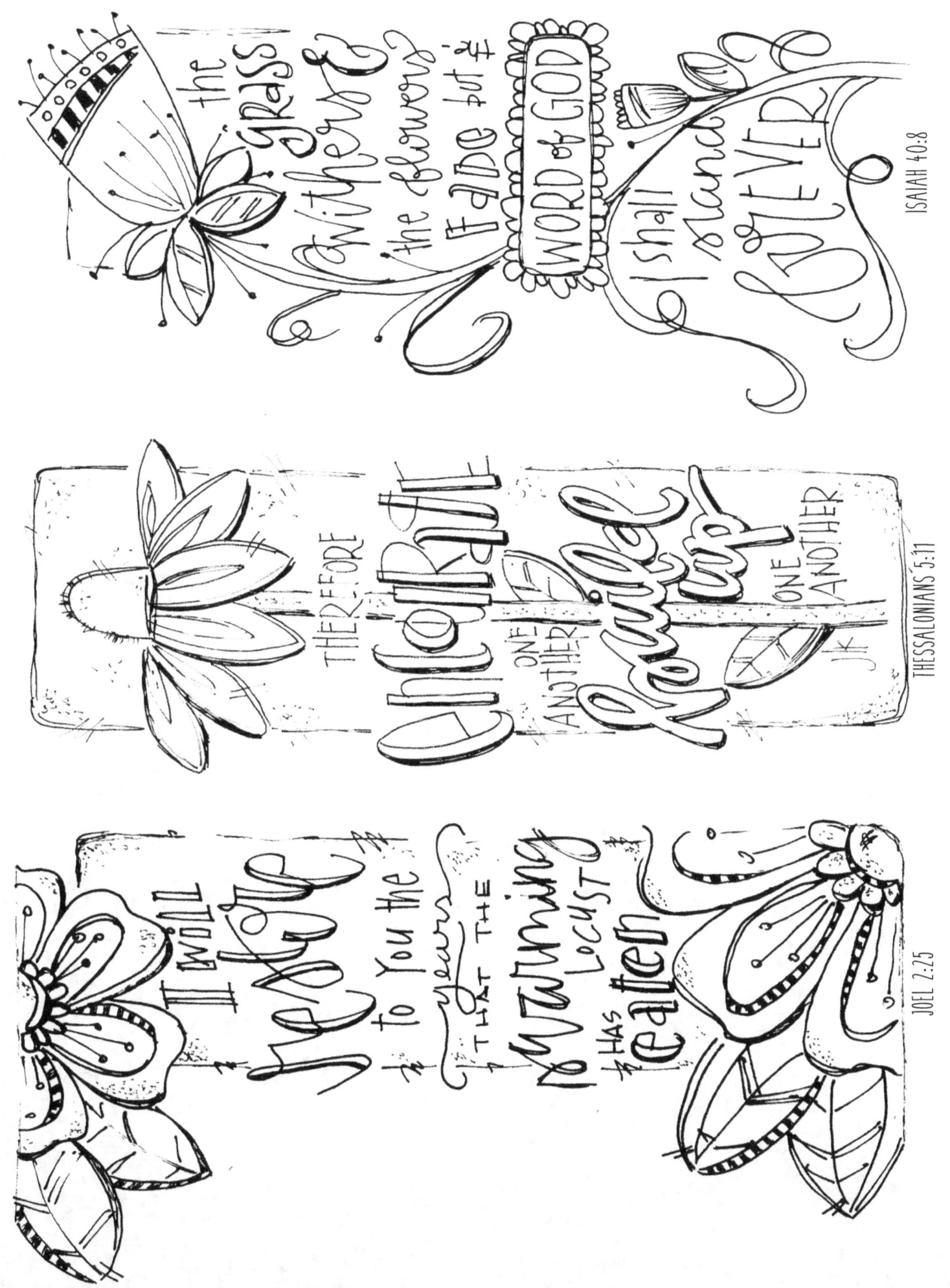

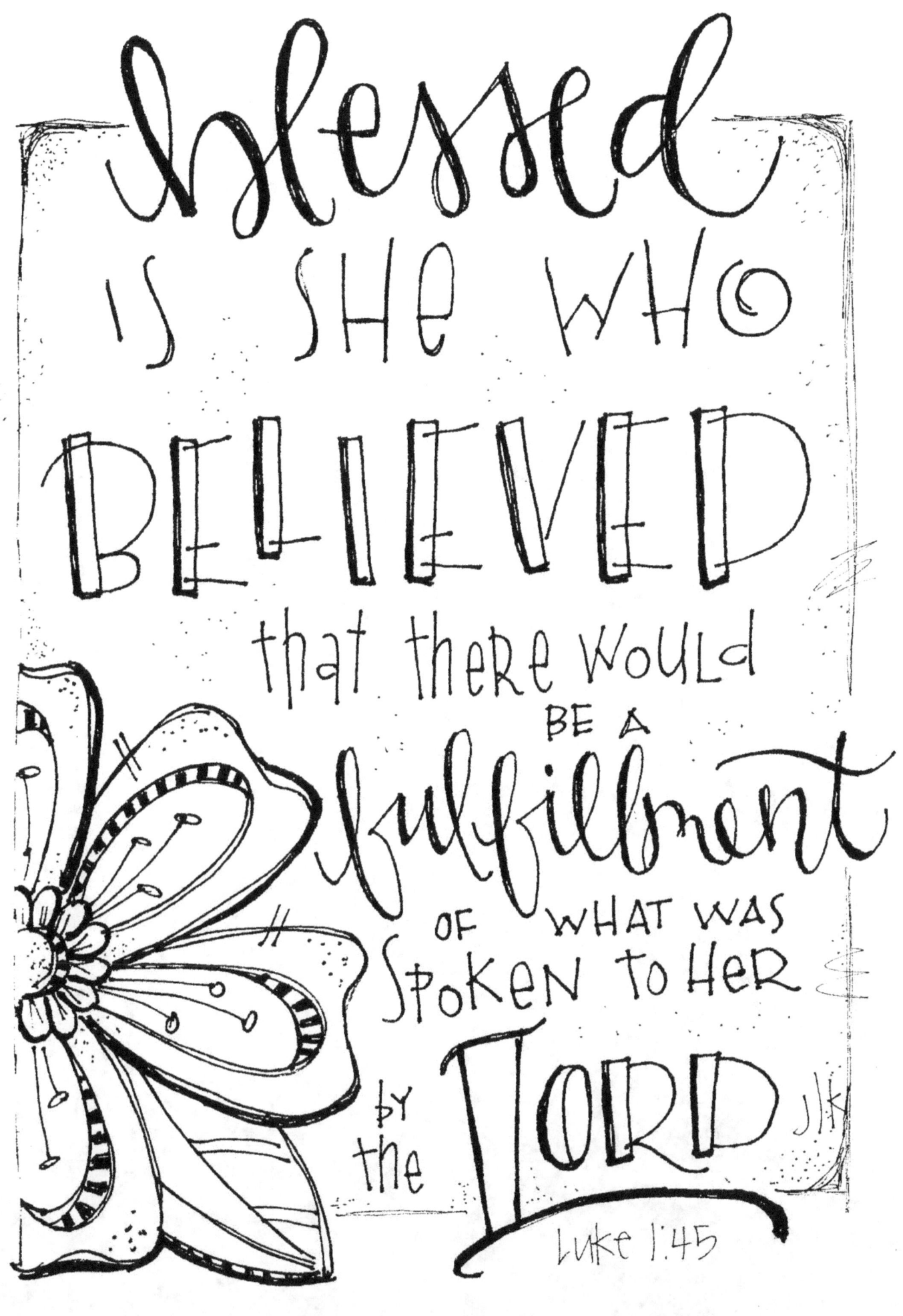

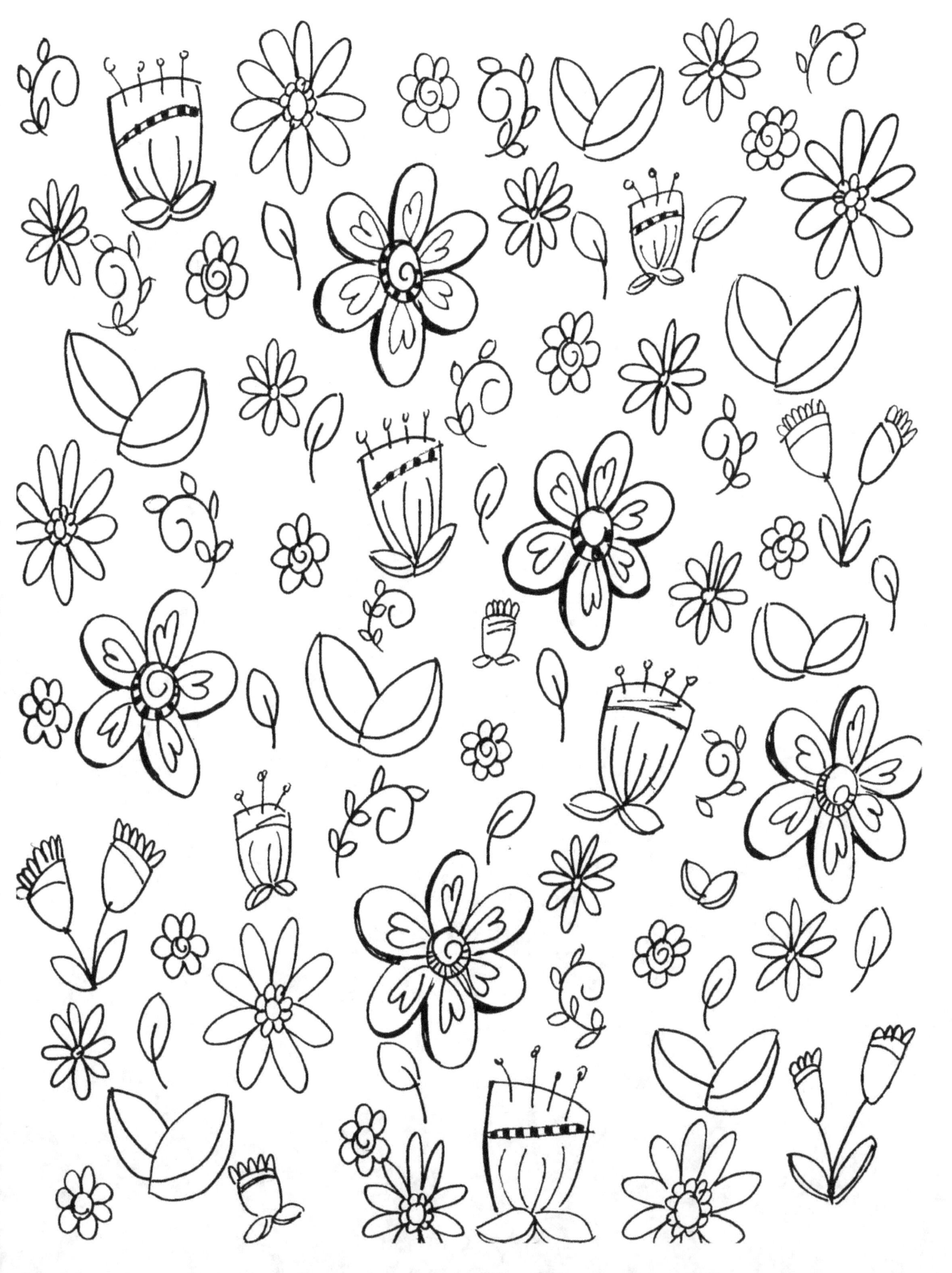

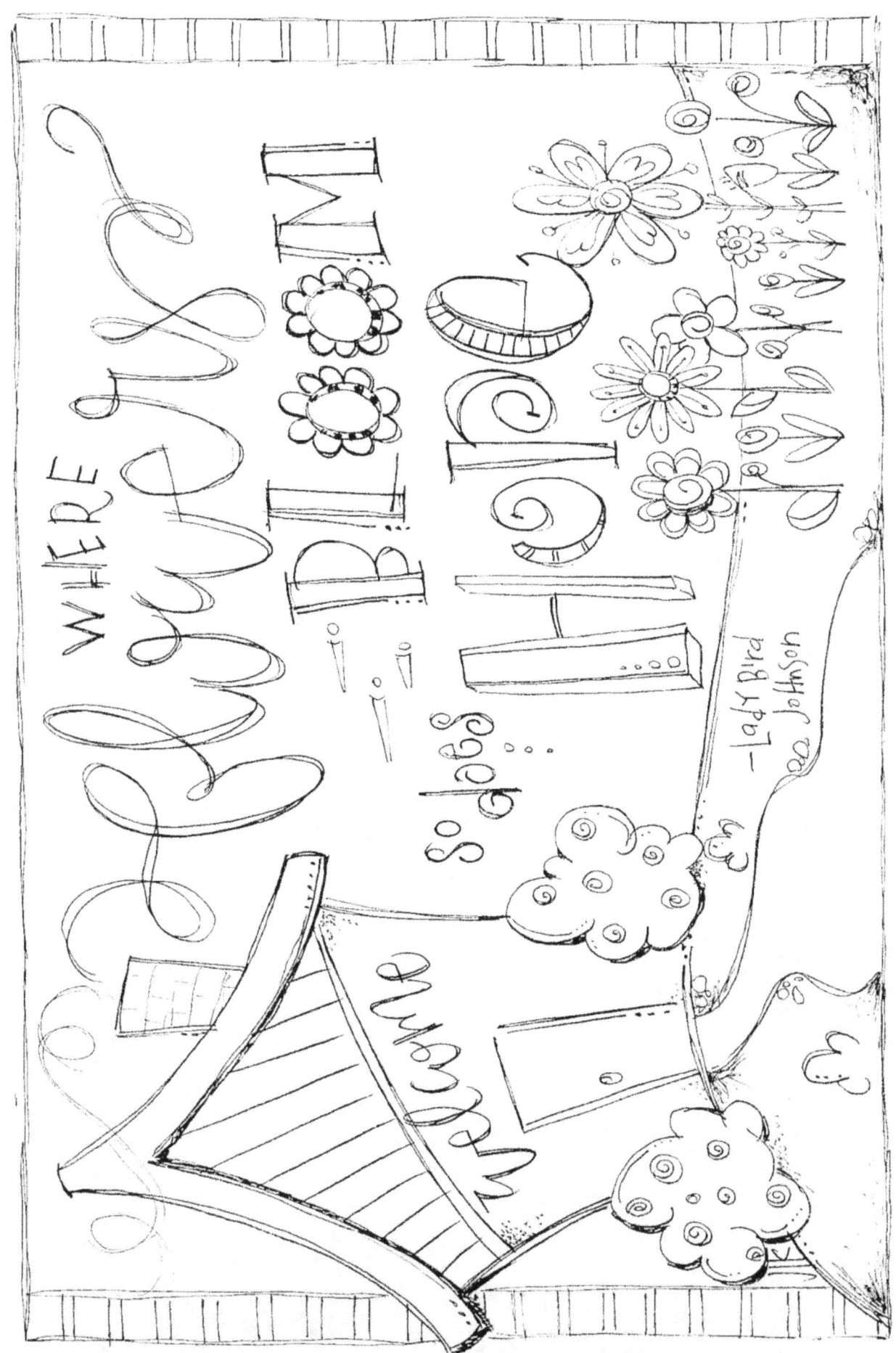

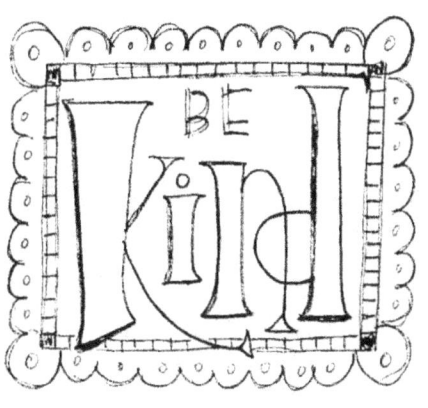
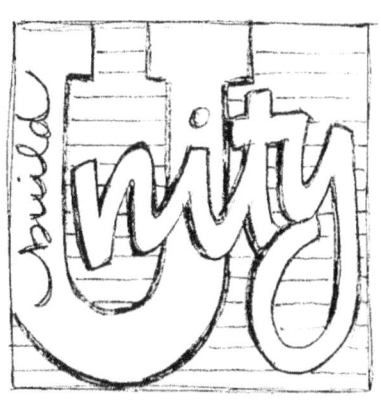
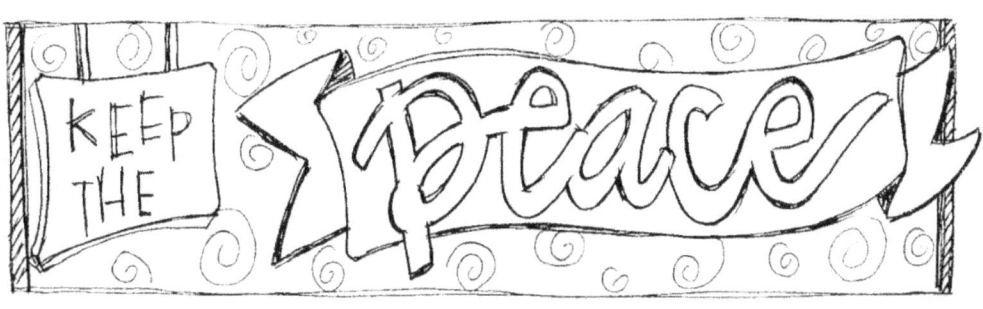
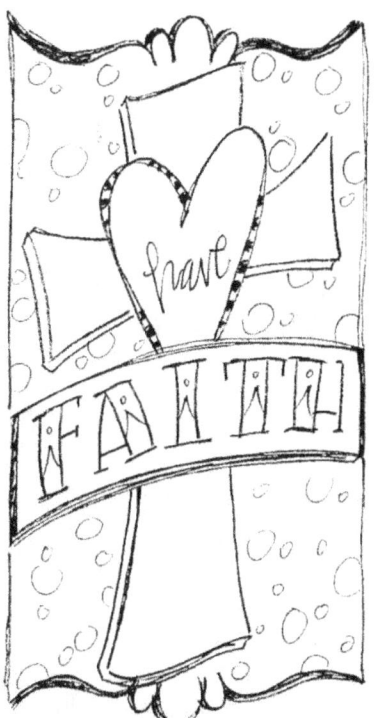
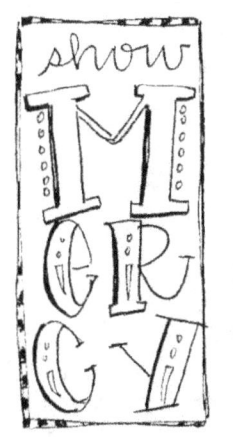
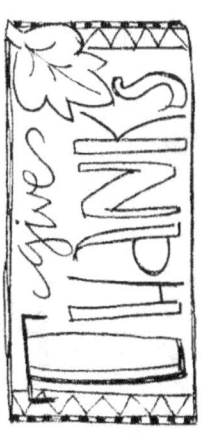
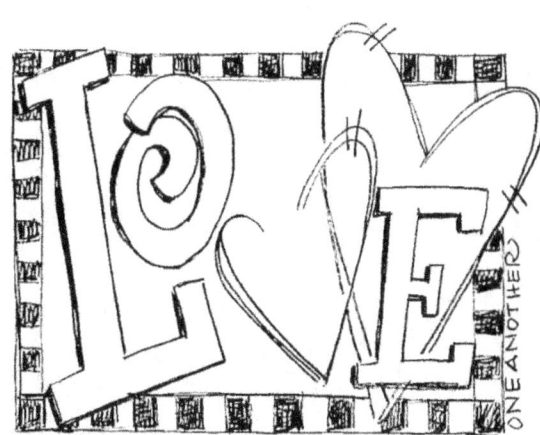
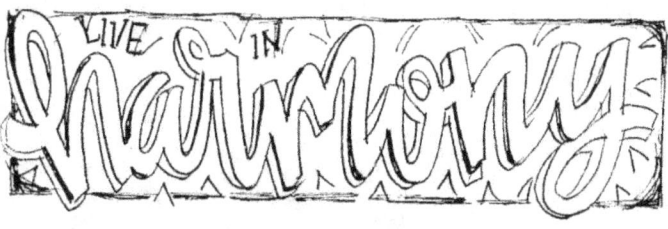
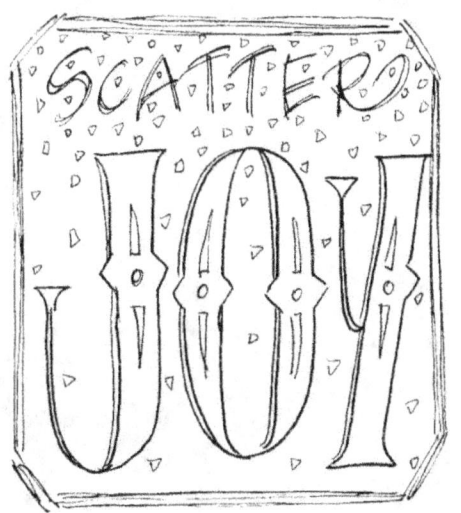

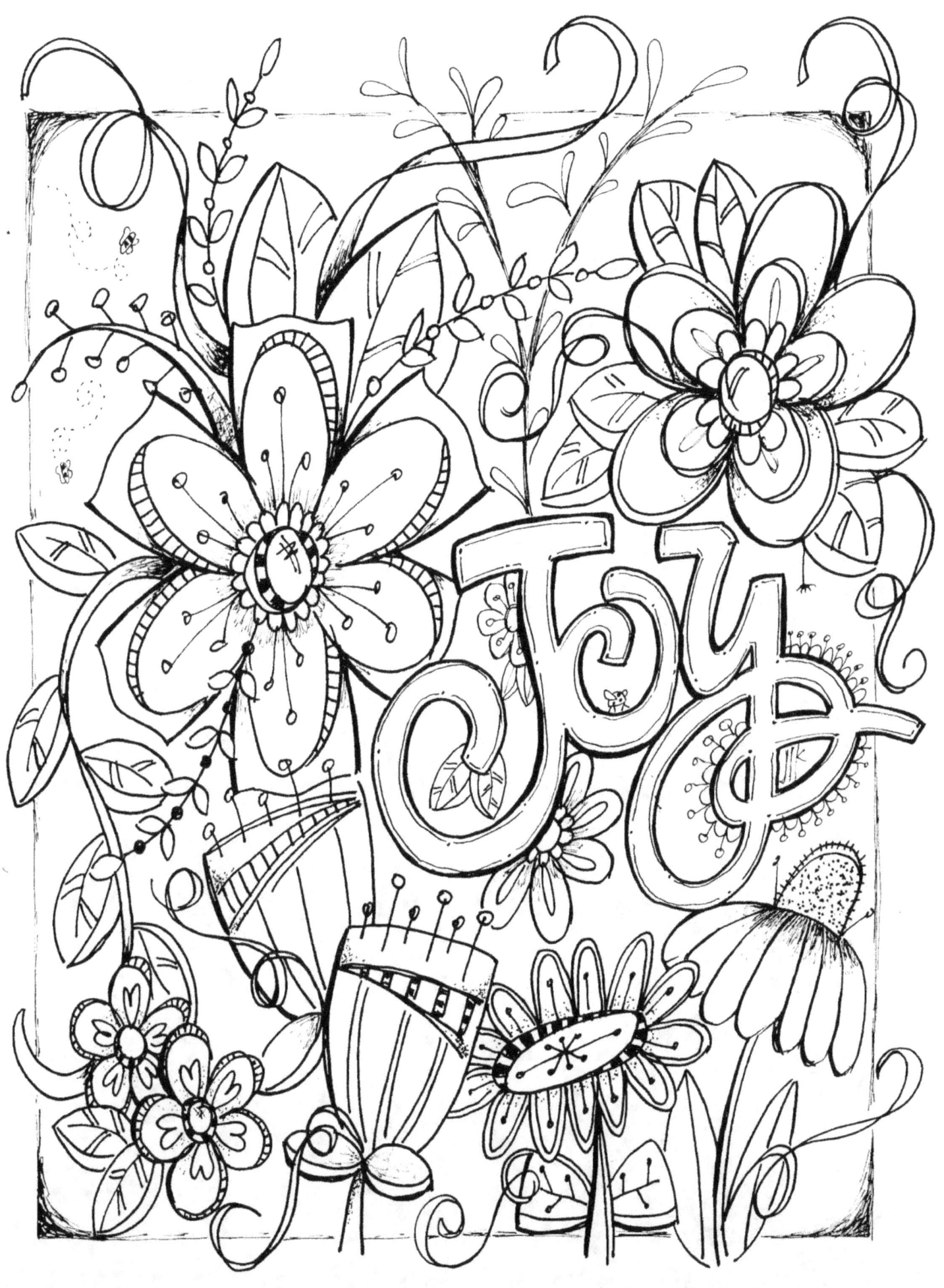

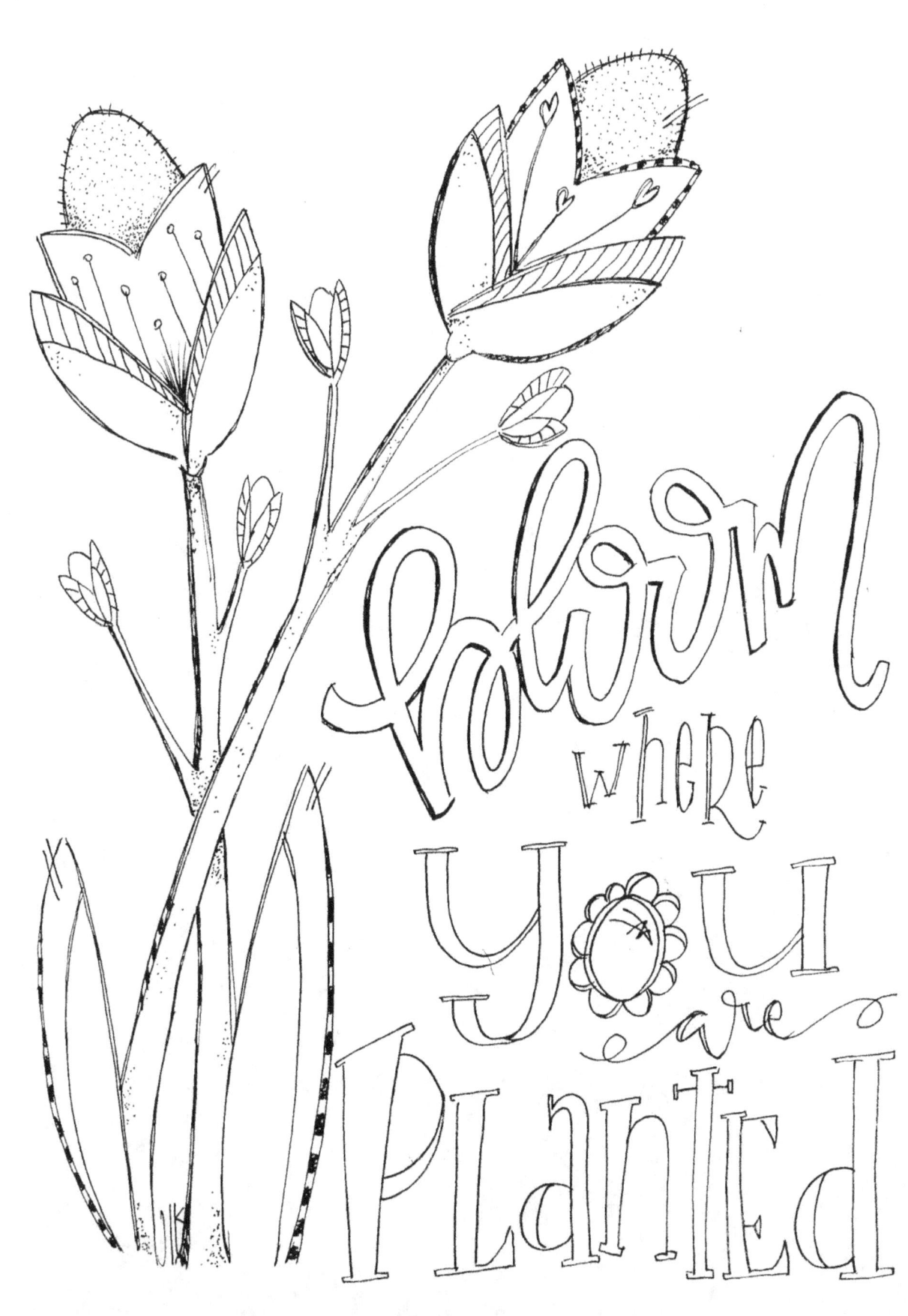

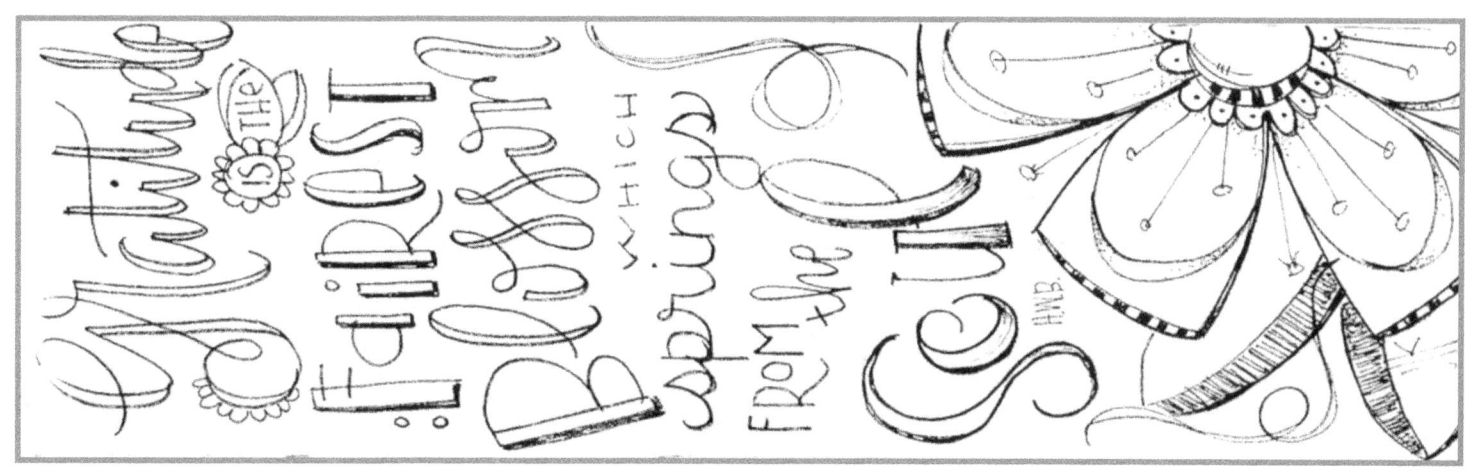

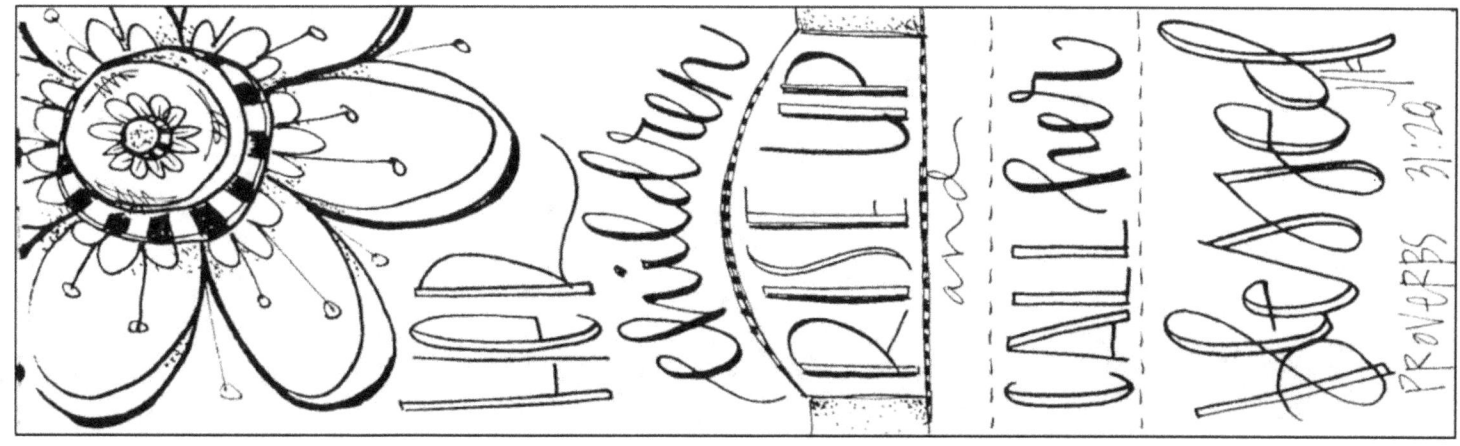

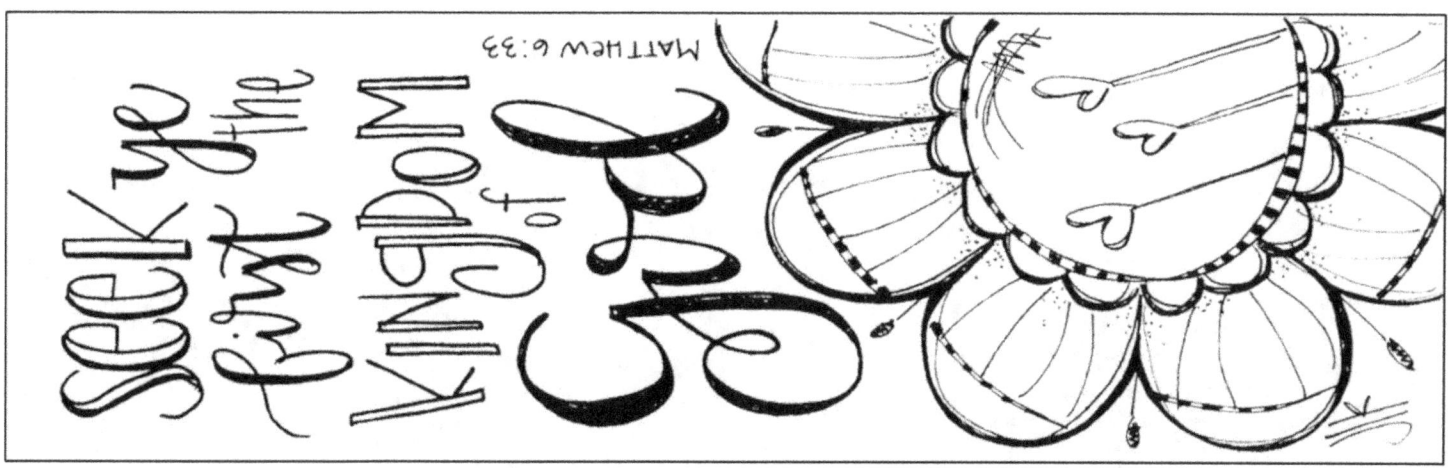

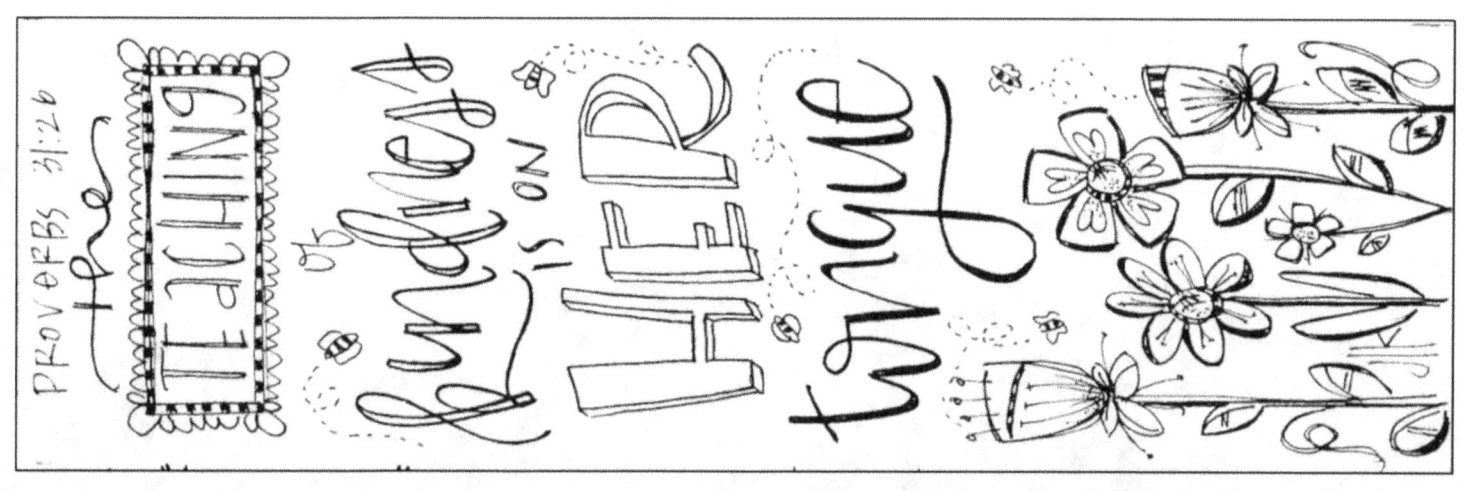

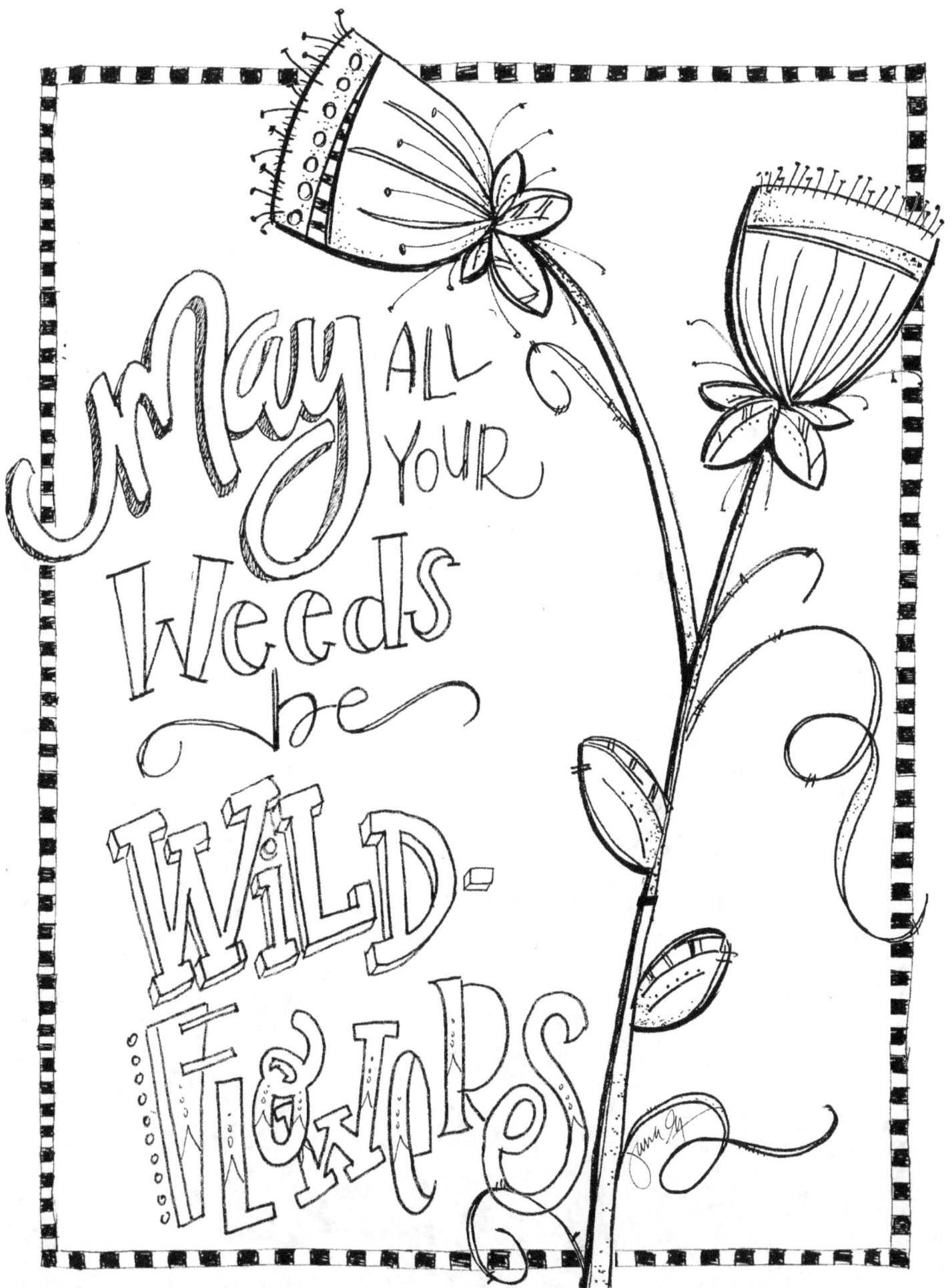

The heavens declare the glory of God & the sky above proclaims his handiwork

Psalm 19:1

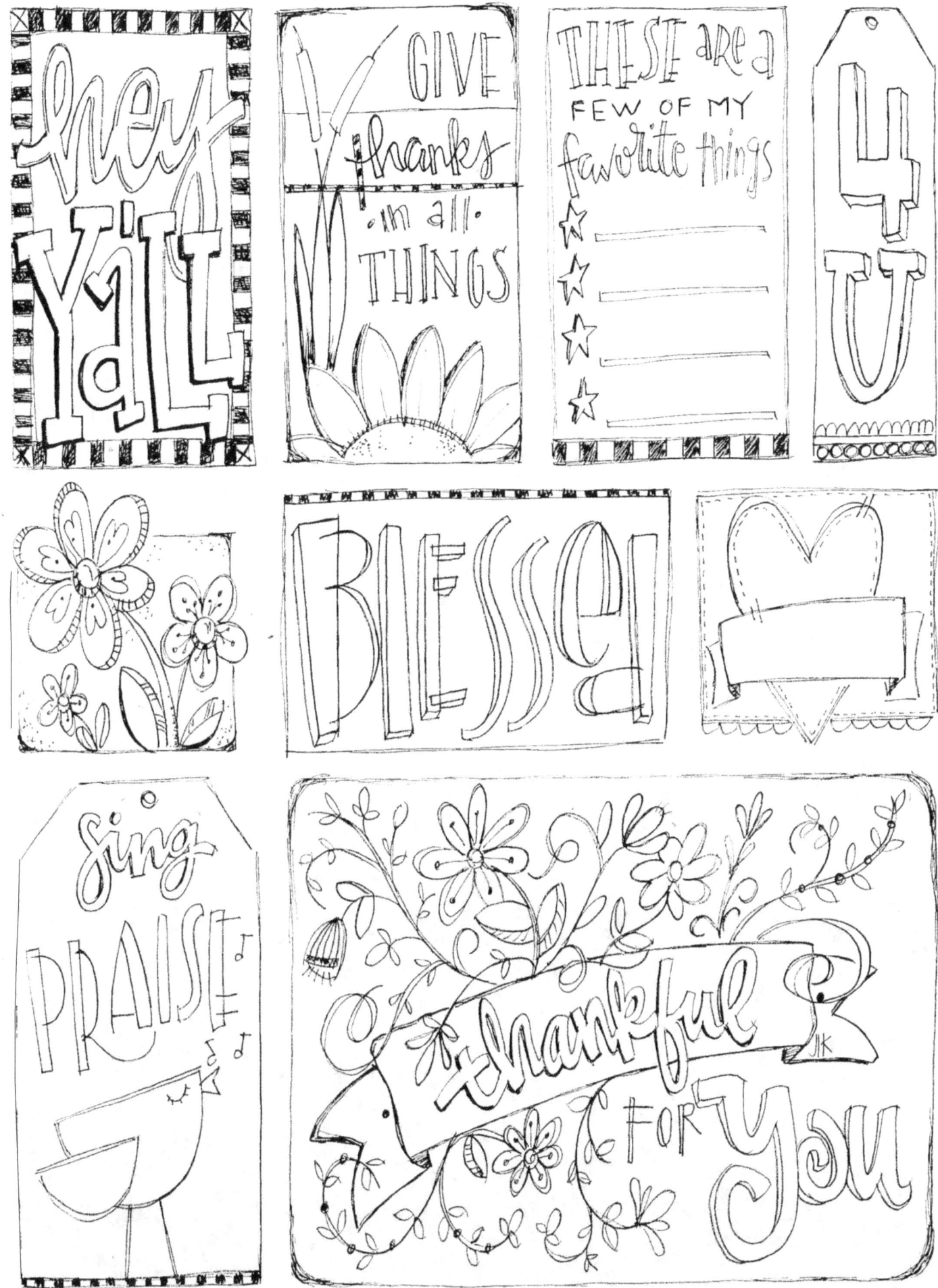

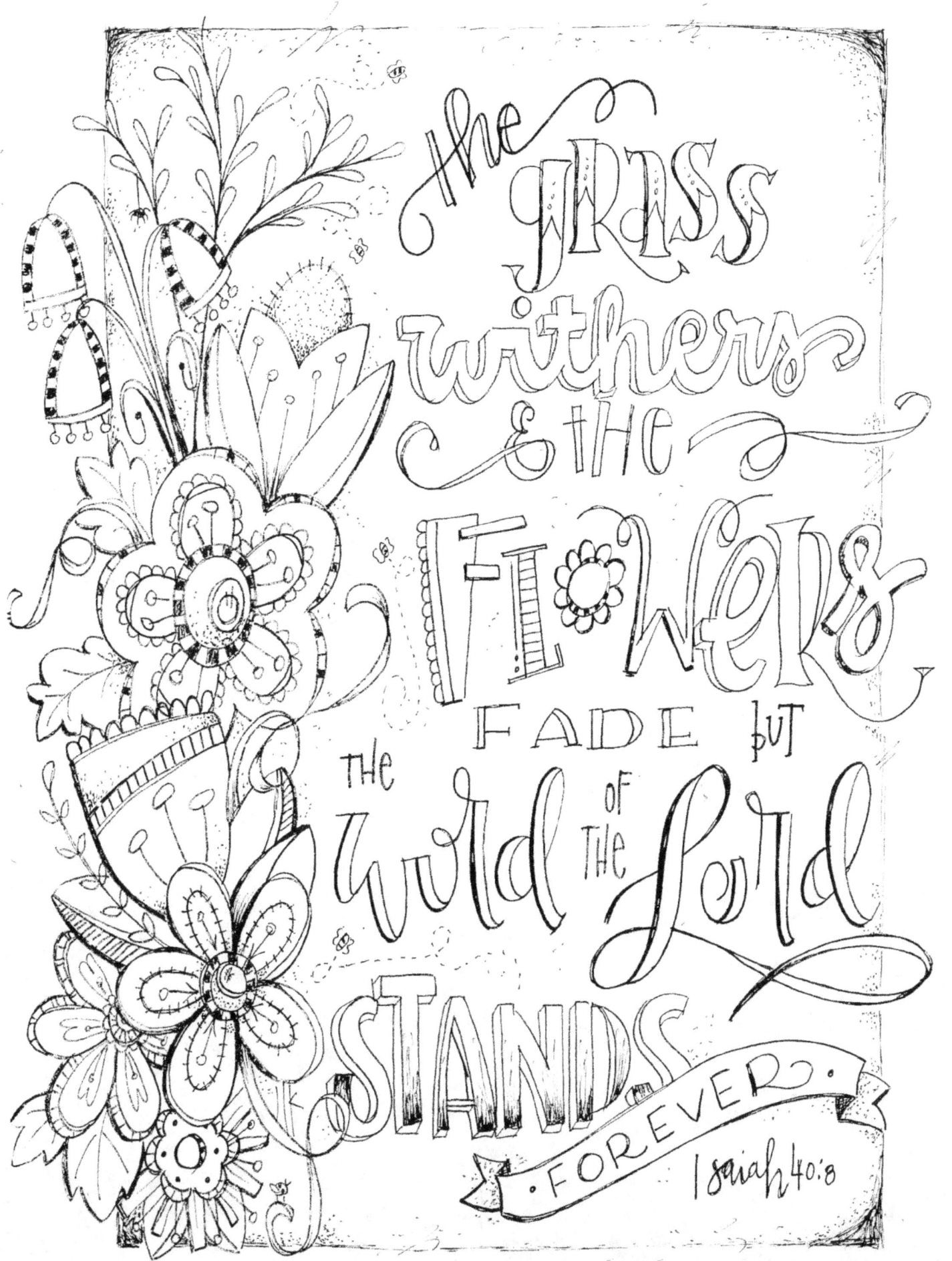

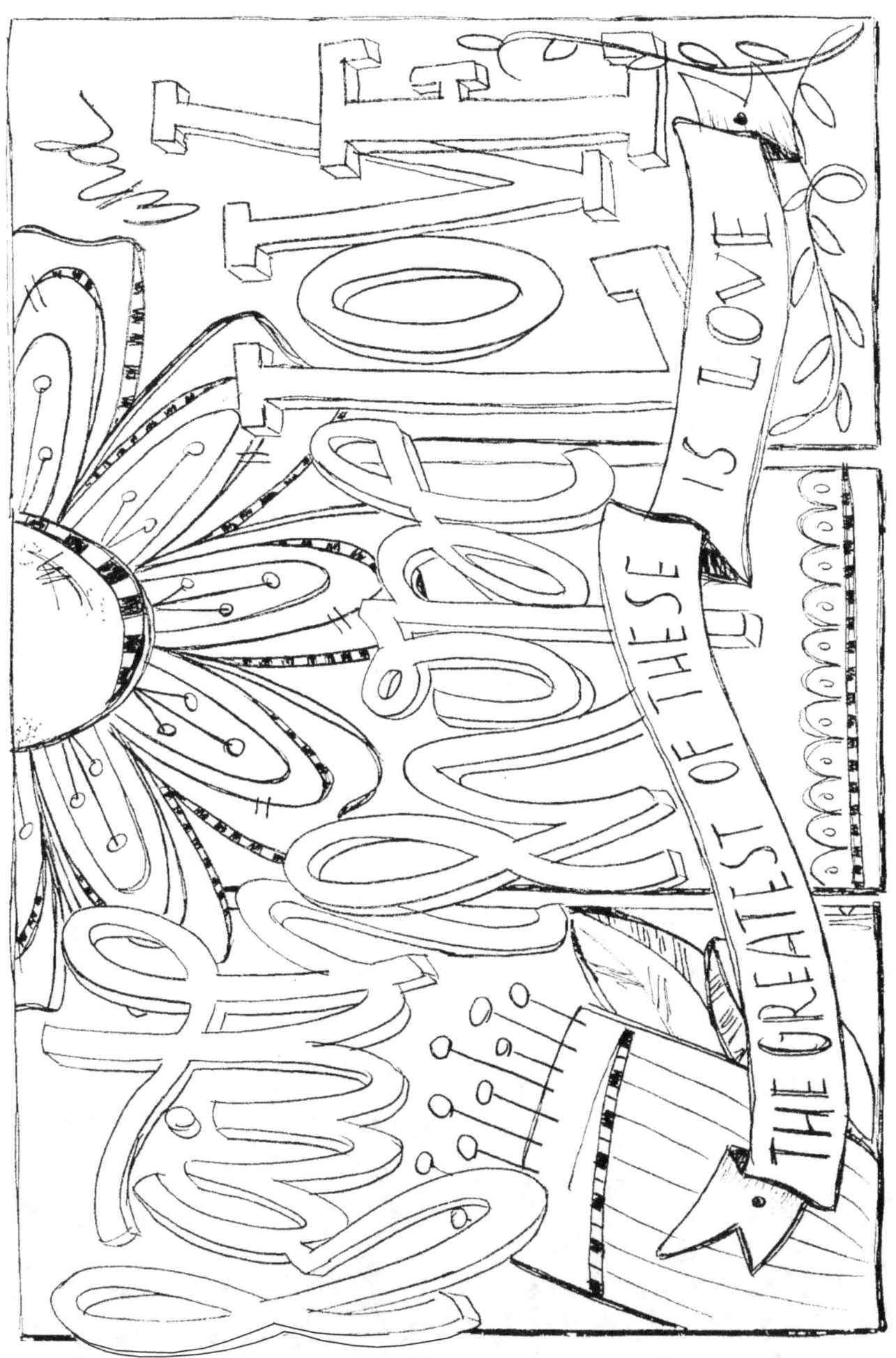

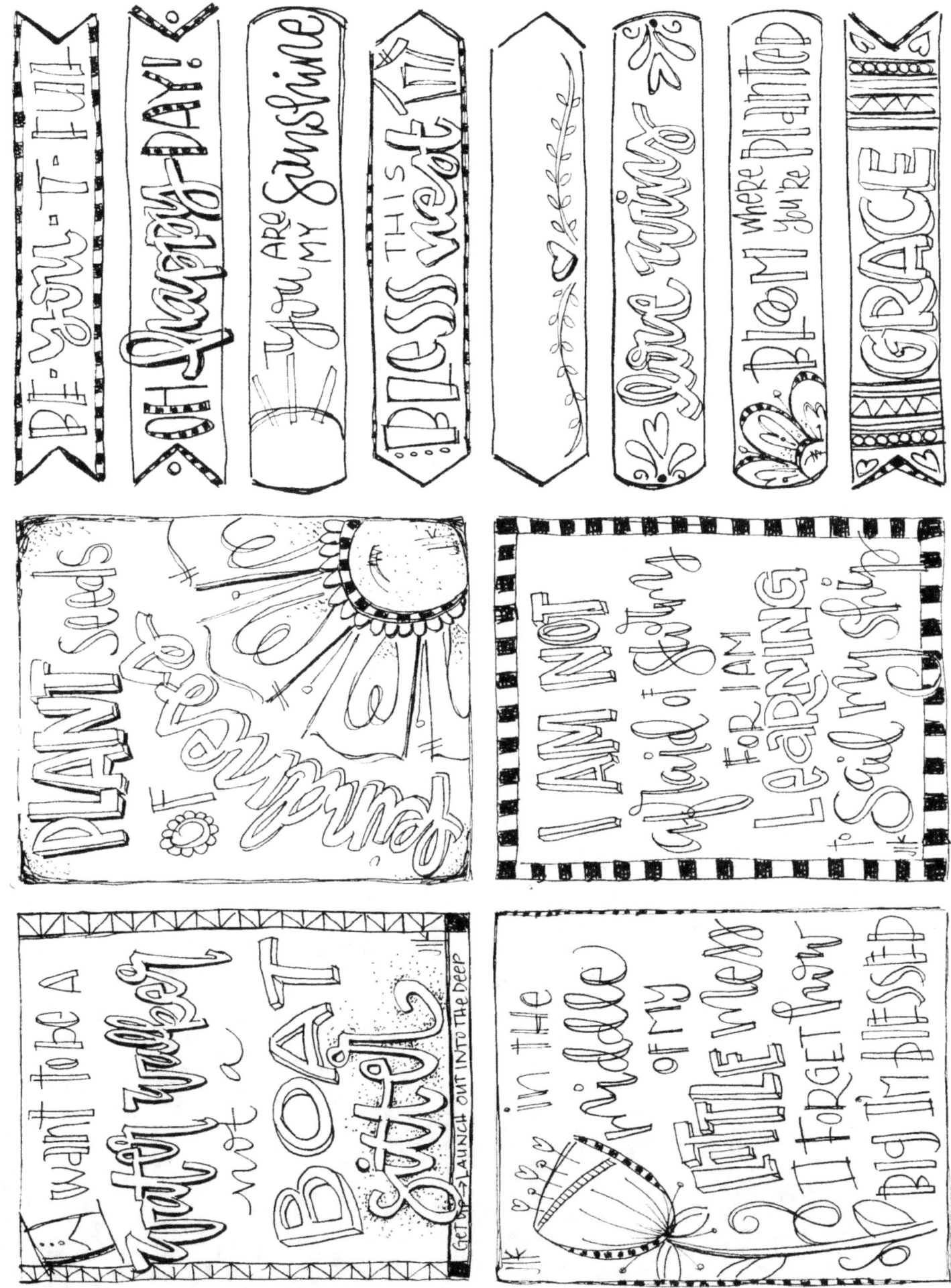

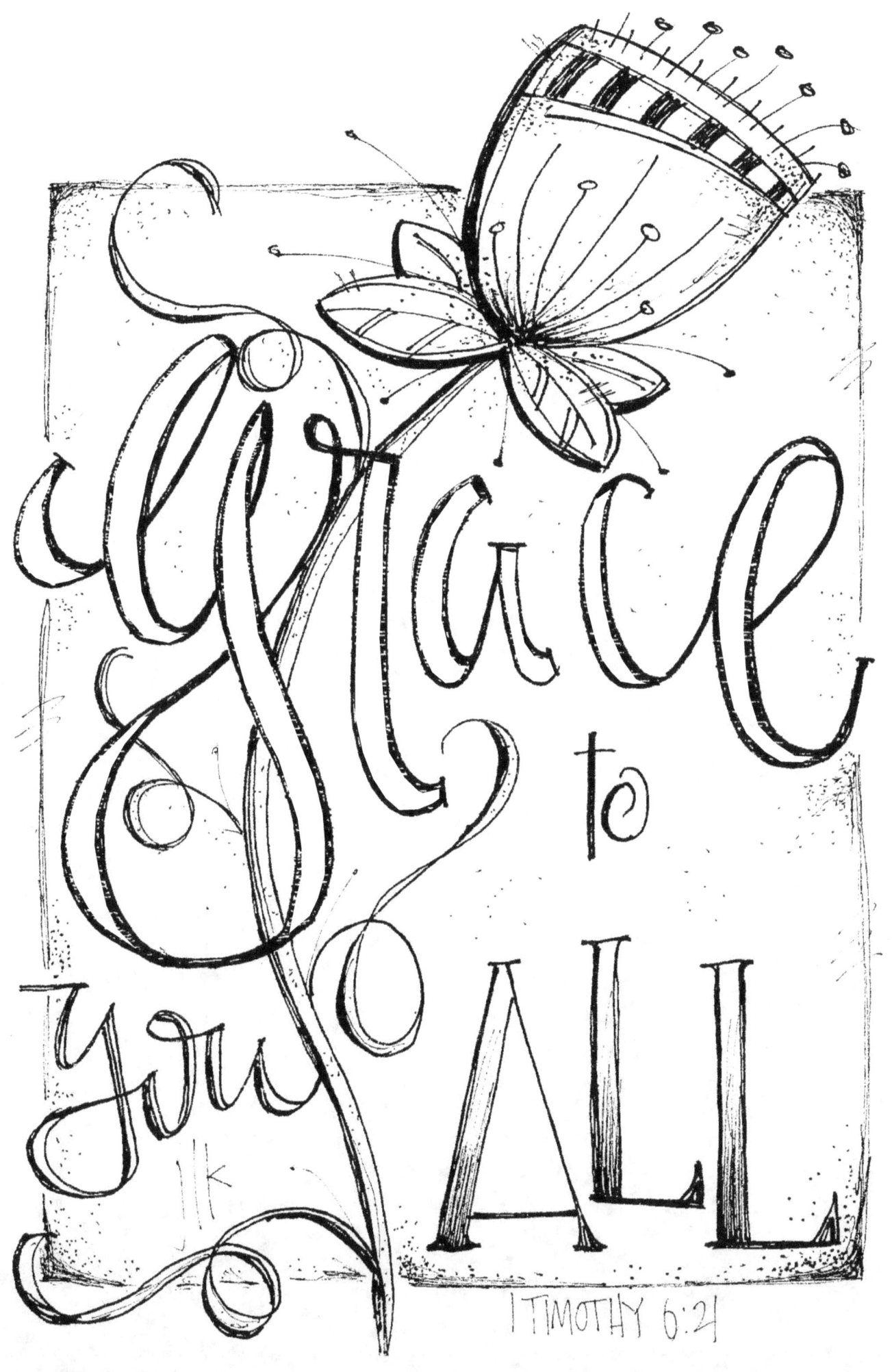

VISIT OUR ON-LINE STORE
TO ACCESS THE FULL LINE OF SOUL INSPIRED

BIBLE JOURNALING TEMPLATES / COLOR YOUR OWN BOOKMARKS,
COLORING PAGES / PRINTS,
AND JOURNALING / SCRAPBOOKING KITS

www.etsy.com/shop/sweettothesoulshoppe

Visit our website at www.SweetToTheSoul.com

www.ingramcontent.com/pod-product-compliance
Lightning Source LLC
Chambersburg PA
CBHW081133180526
45170CB00008B/3094